Φ

AARON
SISKIND

James Rhem

Aaron Siskind's towering presence in the landscape of twentieth-century American photography rises from two foundations of accomplishment and influence – his art and his teaching. Beginning in the early 1930s and continuing until his death at eighty-seven in 1991, his copious production of varied and highly creative images created a legacy of original vision which eventually obliterated whatever line might still have seemed to segregate photography and painting in the 1940s and 1950s. While he is often compared to such Abstract Expressionist painters as Willem de Kooning, Barnett Newman and Franz Kline, with whom he was good friends, the records show that Siskind's photographs had as much influence on their work as theirs had on his. Siskind's manner of zooming in on visual details and fragments in ways that explored gesture and shape but that had little to do with the nominal subject matter in front of the camera clearly made him a brother in the family of Abstract Expressionists.

If Siskind had lived his life as an artist only, his place in photography's history would be secure, but he was also one of photography's most influential teachers in the twentieth century. Preoccupied neither with technical concerns nor with experimentation for its own sake, Siskind provided his most powerful lessons through his own example as an artist by exploring the various terrains of existence through the lens of a camera. He taught for almost forty years, most notably at Chicago's Institute of Design (successor to the New Bauhaus founded by László Moholy-Nagy in 1937) and later at the Rhode Island School of Design. He began teaching photography long before interest in the medium boomed in the 1960s, and taught right through its heyday. Even now, nearly every area of photographic education reflects his influence.

Siskind's double achievement as artist and teacher reflects a number of other dualities – or, more precisely, dialectics – that defined him. He described a number of these over the years in taped interviews and various essays and artist's statements, referring, for example, to 'pleasures' versus 'terrors', to the 'personal' afflicted with the 'bogeyman' versus the 'pure' and the 'unafraid'. A further dialectic can be seen in Siskind's need to be alone to work and think versus his strong need for community and companionship. Working as both artist and teacher, he was able to address these needs. Few artists, in fact, have balanced these roles with such success, and Siskind's success almost certainly stemmed from the fit between his needs as an artist and the demands of teaching. No one could party, dance or enjoy food and drink with greater abandon than Siskind; yet a nagging sense of inadequacy, of loneliness and a need for acceptance followed him into old age. In one of the last of many recorded interviews Siskind gave during his career, he begins to laugh as he reflects on these feelings: 'My friends will hear this and say, "Who doesn't feel this way?" But Siskind did not just recognize the dualities of life, they gripped him with strong emotion throughout his life. They were the engines driving both his art and his teaching.

Though he admitted to them often enough, few could believe how real Siskind's doubts and uncertainties were to him. 'I'm happy a great deal of the time,' he told an interviewer in 1974, 'happiest when I'm with people, friends sitting around a table.' Only those who were very close to him understood the importance of the loneliness he felt but did not show. As a teacher, he always seemed completely relaxed and professionally assured. Even when he became very close to his students, however, he found that '[they] don't believe the feeling of fear before and tiredness after teaching a class. [When I go into

class] I'm coming out of the dark into the light all the time, and back into the dark all the time ... I think that's the way my whole life has been really.' In making his pictures, too, Siskind dared to be alone both emotionally and socially. In the 1940s, apart from Moholy-Nagy and like-minded artists associated with the New Bauhaus, no other photographers in America were creating photographs like his. When he was photographing, Siskind entered a realm of concentration and wordless emotion that left him exhausted at the end of a day's shooting. In that world, however, he was seldom lonely. It was full of the contending passions that drove him; yet it was a place where he could bring order to them, harness their beauty, frame their meaning. His images ask viewers to make a similar journey. The signature Siskind photograph – an abstraction drawn from markings or peeling posters or paint on a flat wall – confronts viewers with a world hidden within the world they already inhabit.

Like many photographers, including W. Eugene Smith and Ralph Eugene Meatyard, Siskind embraced music as a teacher. Early on in his life, he had dearly longed to be either a musician or a poet and had tried his hand at both before concluding that he did not have the talent for either. But the ideals represented by those arts always guided him in his photography, and the form and rhythm of gesture, shape and tonality in his pictures became his music. As far back as his early documentary work in the 1930s, Siskind's ideal when making a picture was not political or even documentary in a literal, illustrative sense. What he had in mind, he said, was 'a Mozart sonata'.

Siskind was born on 4 December 1903 in New York into a family of Russian Jewish immigrants. His father, a tailor with a limited education, ran a series

of increasingly unsuccessful shops. Finding his home life unexciting, Siskind spent much of his youth roaming the streets, responding to the intellectual and social stimulation he found there. His devotion to beauty, discovery and expression marked him as an artist from the beginning, although, at first, words were his medium. The socialist ideals of justice and equality appealed to him, as did the many sidewalk speakers espousing them from soapboxes on upper Broadway. By the age of twelve Siskind had his own soapbox and was attracting a regular audience.

While he was a student at City College, Siskind's involvement with words shifted from speeches to poetry. He was part of the Clionian Society, a literary club whose members included the painters Barnett Newman and Adolph Gottlieb. In addition to reading each other's poetry, the group often attended free concerts at the Metropolitan Museum of Art and then strolled through its galleries. These outings gave Siskind his first serious exposure to art, and he learned about it eagerly from the other club members who already knew a great deal. He became particularly drawn to Renaissance and Gothic art and architecture. Although not religious in the traditional sense, Siskind developed the habit of visiting the chapels of the enormous and still unfinished cathedral of St John the Divine on Amsterdam Avenue in upper Manhattan, not far from Harlem. He spent hours there 'just being still', and it was through art that he developed a strong sense of the importance of symbol, icon and ritual, a sense felt throughout much of his photography.

After graduating from college in 1926, Siskind took a job teaching English in the New York public school system, his first appointment in a twenty-three-year career teaching elementary students. In 1929 he married his high school

sweetheart, Sidonie Glatter. This marriage, like the two others that followed it, was overshadowed by physical and mental illness. As his wives suffered a variety of illnesses, Siskind felt the often unavoidable dissonance and distance of individuals within the harmony of partnerships and community. Sadly none of these unions flourished long, a fact that underscored Siskind's sense of the loneliness within the human condition. As a wedding present for his first marriage, Siskind was given a camera. He experimented with it during a honeymoon on Bermuda and found he enjoyed it. By 1932 he had purchased a better camera and joined the Film and Photo League in New York City, one of the most influential of the numerous camera clubs in the United States. The growth and progress of such clubs fostered the early years of photography's coming of age as an artistic medium. The members of the Film and Photo League were 'wonderful guys', Siskind recalled, who taught him how to develop and enlarge his photographs.

But despite his basic sympathy with their socialist ideals, Siskind could never abide anything doctrinaire. The organization was avowedly communist, and the more that communist politics intruded on the group's freedom in its use of photography to advocate social justice, the more uncomfortable Siskind became. He finally left the group in 1935. A year later he was persuaded to return to the newly reorganized New York Photo League on the condition that he would not be involved in organizational politics but instead could run a division called the Features Group. Under Siskind's leadership, the Features Group produced a number of photo-series that were staged as public exhibitions at the League's headquarters, including 'The Catholic Worker Movement', 'Dead End: The Bowery' (page 27), 'The End of City Repertory Theater' and 'Harlem Document' (pages 21, 23 and 25).

For Siskind, the Features Group became a practical symposium. While the group remained focused on issues of social justice, he used it to explore aesthetic questions and ways of working photographically. What were the limits of documentary photography? How far could one push aesthetic control of the image and still have it remain true to reality? Could the 'truth' that art might bring to the image be fully wedded to the facts that the camera saw? Siskind led the group in systematically exploring these questions. Instead of keeping ordinary minutes of their meetings, the group kept detailed notes of their discussions, which led to a common vocabulary for assessing the success or failure of their efforts.

As an English teacher by day, Siskind was well equipped for this kind of leadership. Working with the Features Group, he learned how to explore ideas with other artists and how optical fact and artistic truth interacted in photographs. These explorations shaped his future career, both as an artist and as a teacher of photography. The habits of working he developed doing documentary photography – keeping everything in sharp focus and shooting from a simple point of view – never left him. 'I have remained very true to my documentary training,' he recalled in a 1963 interview. By this he meant that he retained 'tremendous faith in the thing itself'. Whatever metaphoric or symbolic energy his images might release, objects in his photographs such as rocks or peeling paint, remained recognizable objects in the real world.

At first glance the photographs Siskind began to produce in 1940 seem to bear little relation to his early documentary work, but he saw it differently. For their documentary projects, the Features Group did a great deal of planning and research. During the 1940s, when Siskind began to make his

mature artistic pictures, he abandoned this kind of deliberate pre-planning and responded more spontaneously to locales and subject matter. As he reflected on the images later, however, he realized that there was a parallel to prior research in his use of prior experience. 'You carry with you a whole museum, so to speak,' he said in a videotaped interview in 1985; 'You have always with you the history of art.'

But there was an important difference. Siskind continued: 'Now it's pretty hard to see how someone can carry the history of art with them and be innocent at the same time. Like Mozart said [speaking of another composer], "... he's got to make music. He just can't [spill something out]." You've got to make music, and the music you make is in terms of what music has been.' Siskind believed that one must study technique and history consciously, as one might train for a race, so that they could gradually become an intuitive part of one's way of working. This was the source of Siskind's discontentment with the documentary assignment: no matter how much they were invested with aesthetic value, documentary images remained too self-conscious. Although he had achieved acclaim as a documentary photographer, Siskind grew tired of this way of working: 'I wasn't made for it really,' he said; 'My documentary pictures are very quiet, very formal.' Looking back over them, he did not find that they contained anything really personal, powerful or special.

In the late 1930s and early 1940s, Siskind had been moving steadily away from overtly agenda-laden images through his architectural work, including a project for Bucks County Historical Society in Pennsylvania and a project called 'Tabernacle City' which focused on a Methodist community of summer retreat cottages at Martha's Vineyard called Cottage City (page 29). The

'Tabernacle City' photographs conveyed a sense of history and latent meaning but not an explicit social message. In these unpeopled images, form and content were clearly becoming one and the same. The Photo League, however, was not evolving as Siskind was, and its members disparaged Siskind's 'Tabernacle City' work. One league member wrote in a comment book at the exhibition in 1941 that Siskind had 'betrayed the Party'.

Undeterred, Siskind continued on his own path, and in the summer of 1943 in the fishing village of Gloucester, Massachusetts he had what he called 'a picture experience' — an epiphany that changed the course of his work for ever. Instead of working from a programme, as he had done on documentary projects, he devoted himself to something that he had already sensed was important — letting objects speak for themselves in their own way. In fact, he had given this very advice to his co-workers in making 'Harlem Document'. As he recalled in his 1945 essay 'The Drama of Objects', he told them that in the moments of making the picture they should 'become as passive as possible', 'de-energize' their ideas about the subject and let it speak for itself.

In Gloucester Siskind went a step further: he began without any conscious ideas that he would then have to forget in order to photograph in this new way. Instead he substituted the discipline of a fixed working routine that had nothing to do with the things he would photograph. Each morning he walked out with twelve sheets of film, enough to make six pictures, two exposures for each. He worked within a very small area, covering no more than a single wharf or block of the village. When he printed the photographs that winter, he saw something unexpected. In an interview in 1963, he recalled those

moments: 'To put it on a higher expressive plane: there was, in a sense ... a revelation to me. I made some pictures and these pictures revealed meaning to me, a way of making a picture ... which I had never dreamed of before. Well, when that happens to you, you've just got to follow.' 'I didn't push photography,' he said, 'photography, in a sense, led me.' Siskind saw how he could move fully from the sphere of description to the plane of ideas in abstracted form. He saw in what he had done – framing organic objects within strong geometric compositions – a reflection of a basic duality he had long puzzled over. 'In the pictures you have the object,' Siskind continued in the 1963 interview, 'but you have in the object or superimposed on it, a thing I would call the "image" which contains my idea. And these things are present at one and the same time. And there's a conflict, a tension. The object is there, and yet it's not an object. It's something else. It has meaning, and the meaning is partly the object's meaning, but mostly my meaning.'

It has been argued that photography emerged as an inevitable result of the long quest in the visual arts to achieve single-point, three-dimensional perspective within the two dimensions of a flat picture plane. Ironically, Siskind had discovered that his growth as an artist demanded that he discard this hallmark of photographic technology. In the 'flat, unyielding space' of the perspectiveless picture plane, as he described it in 'The Drama of Objects', he could represent his 'deep need for order'. Here, objects 'cannot escape back into the depth of perspective. The four edges of the rectangular [space] are absolute bounds. There is only the drama of the objects, and you, watching.' In 1945 and for many years afterwards, Siskind's photographs seemed a radical departure from his documentary work, having more to do with painting than photography. Speaking to the History of Photography class at Columbia

College in Chicago in 1982, Siskind recalled that, 'for a long time [Garry] Winogrand went around saying, "Siskind isn't a photographer – he's something else."' With a chuckle, he added, 'He's stopped doing that.' Reflecting on his place in photography's history in the 1985 videotaped interview previously mentioned, Siskind said that, 'In the course of the history of photography we were [in the 1930s and 1940s] at a period when people were emphasizing the sociological and psychological and things like that, but there was a time before when they made pictures which were metaphors, symbols.' He did not see himself as being revolutionary: 'It was just that I brought some elements of the past forward,' he said.

By 1949 Siskind's commitment to photography dominated his life; so much so that when an opportunity to teach photography one day a week for a minimal income came along, he gave up the financial security of his public school job teaching English and forfeited his pension in order to pursue it. He had already had exhibitions at the Charles Egan Gallery in New York, where de Kooning, Kline and other prominent Abstract Expressionists showed their work. It was clear that Siskind was an artist; it was not clear how he was going to make a living. A persistent invitation to come and teach in Chicago from photographer Harry Callahan, then head of the photography programme at the Institute of Design, solved this problem while allowing Siskind time to pursue his art. It also allowed Siskind to apply his gifts as a teacher to photography. Initially, Siskind did not want to leave New York and his community of artist friends, but his twenty years in Chicago (1951–71) turned out to be perhaps the happiest and most fulfilling of his life. Every aspect of his talent and personality found fulfilment there, and he forged a lifelong friendship with Callahan that has become one of the most legendary in the history of

photography. His first book, *Aaron Siskind: Photographs*, was published in 1959. In 1966, at the age of sixty-two, he received a Guggenheim Fellowship to photograph in Rome the following year. He co-edited *Choice*, a magazine devoted to poetry and photography, and he continued to exhibit widely in increasingly prestigious venues.

The legacy of Siskind's Photo League days also re-emerged in the imprint Siskind made on the curriculum at the Institute of Design. When Siskind arrived, he both liked and disliked what he found in the famous 'foundation course'. He liked the exercises developed under the influence of Moholy-Nagy, and he kept these, changing almost nothing about the course when he began to teach it. But he did not like the emphasis on the idea of the 'experimental' that enveloped the course. Although he did sometimes use such devices as multiple exposure and blurred motion, he consistently said that he never experimented. For Siskind the idea that he wanted to predominate in students' minds (as in the artist's mind) was that of the 'picture concept'. In an interview in 1970, he said that, in teaching these devices, he stressed to students that, 'sooner or later you've got to have some kind of picture concept that's congenial to [the devices], that's where the meaning is'. His idea of the 'picture concept' had nothing to do with vaunted notions of pre-visualization; instead, it described an experience of spontaneous discovery. For him, the semantic differences between 'experiment' and 'serendipity' reflected very different states of mind and centres of value. Thus, while Siskind left the foundation course unchanged in most ways, he repositioned it conceptually.

Siskind emphasized the idea that students should search within themselves for their own vision, rather than hoping to find it in experiment for experi-

ment's sake. As in composing music, however, such a search required discipline. Together with Callahan, Siskind introduced the individual project to the curriculum. For beginning students these projects might actually be contributions to a group project, but for advanced students the projects became their theses. Examples included work with the Chicago housing authority as well as documenting the architecture of the Chicago School architect Louis Sullivan.

Siskind and Callahan functioned so harmoniously as teaching colleagues that students thought of them as a single entity with two manifestations. Siskind was the educator; Callahan was head of the programme, but some students thought Siskind was. Siskind called meetings, served on committees and organized projects. In 1963 he helped found the Society for Photographic Education, a national organization, followed in 1969 by the Visual Studies Workshop, located in Rochester, New York. Siskind could almost always be found at the Society's annual meetings; Callahan almost never. Callahan seldom let students see his own work; Siskind was not at all shy about it.

Weary of academic politics, Callahan snapped up an opportunity to teach at Rhode Island School of Design and resigned his position in Chicago in 1961. With a similar weariness, Siskind would join him at RISD in 1971, but in the intervening decade, as interest in photography in America continued to grow, Siskind led the Chicago programme without Callahan. As before, he shaped the curriculum towards the development of the individual artist-photographer. While student applications and teaching and administrative duties increased, so did the acclaim and attention Siskind received. That acclaim reached a high point in 1965 when the George Eastman House in Rochester, New York

mounted a retrospective exhibition featuring two hundred of his photographs made between 1933 and 1963. Siskind would live another twenty-five years teaching, creating new work and mounting significant exhibitions, but by that time he was already a 'grand old man' of photography.

Siskind was an artist whose vitality sprang from embracing fierce dualities at every turn. Like William Blake, one of the visionary English poets he much admired, Siskind felt that competing dualities were reconciled only in the grave. Even art did not fully reconcile them; in fact, he believed that art depended on the tension between them. As he wrote of his images in 'The Drama of Objects' in 1945, 'Aesthetically, they pretend to the resolution of these sometimes fierce, sometimes gentle, but always conflicting forces.' In contrast to the clamour of Chicago, the quiet of Providence, Rhode Island, was sweetened for Siskind by the presence of Callahan and his wife, Eleanor. At RISD, he continued to teach and work, an undiminished and ever-fresh influence on photography. In 1984, reflecting his devotion both to the medium and to its future students, he established the Aaron Siskind Foundation to inherit his prints and to use the income from their sale to fund fellowships and other support for contemporary photography. On 8 February 1991 Siskind died in Providence at the age of eighty-seven.

May Day Parade, 1932. Between 1929 and 1932 Siskind experimented on his own, not reading much about photography but simply making photographs and thinking about them. This image, made before he joined the Film and Photo League, appeared in 'America Today', an exhibition that the League mounted in November 1933. It was the earliest public exhibition of his work. Here, as in his later work, the photograph's power derives from the framing and the metaphorical power of shapes. The policeman's horse imposes two kinds of order within the picture – one aesthetic, the other documentary. The frame within a frame that it creates elevates the picture above simple illustration by opening a dialogue on the place of power and authority in maintaining order in a free society.

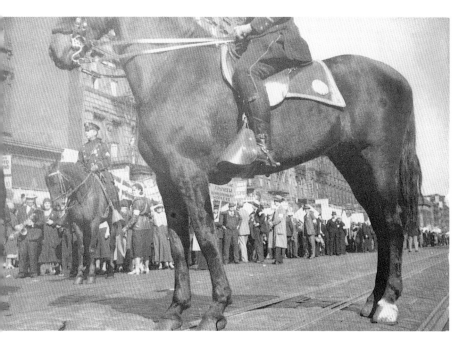

Two of My Students, c.1932. Here again Siskind uses a frame within a frame to organize and enliven the elements of his photograph. The curving frame around the windows in the building in the background echoes the curves and sense of movement in the girls' profiles. But while the elements in the picture harmonize, a tension exists between them. The frame around the windows seems to sweep backwards to the right, while the girls are facing left, smiling brightly. Contrary tensions transform the image. Symbolically, the image looks to the past as well as the future. Siskind made the image as part of his early experimentation with the camera, however it also engages his long-standing concern with civil rights and racial equality.

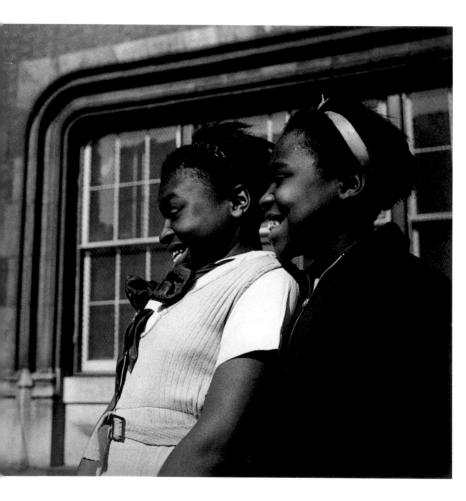

Harlem Document, c.1935. Siskind's focus on architecture as expressive subject matter in his photographs continued through his entire career. This formal study of a brownstone façade in Harlem anticipates similar façade studies Siskind would create in Chicago thirty years later. Here, however, the windows – only two of which are not boarded up – convey a sense of options that have been largely foreclosed for certain social groups, an idea consonant with the view of social conditions that the Photo League sought to convey not only in 'Harlem Document', but in all its Feature Group projects.

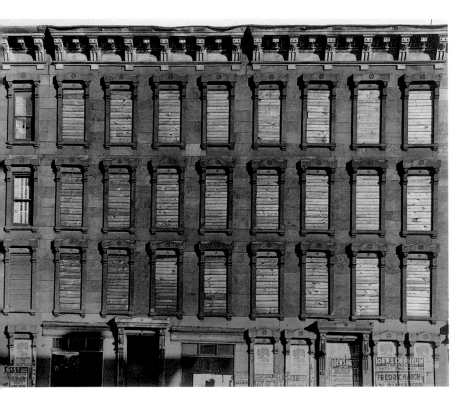

Harlem Document, c.1935. This very formally organized photograph quite literally reflects an image of dignity in the face of adversity. One may almost miss the crutch held by the young man in the mirror, he holds it so acceptingly. Siskind pictures him surrounded by a loving community, symbolized by the photographs in small heart-shaped frames on the neatly arranged dressing-table and stuck into the edge of the mirror. The sconce contains only one working light bulb, just as the young man may have only one good leg, but the knotted tie and coat speak of dimensions in this person's life that surfaces can only imply. The image reflects the rapport and co-operation the Photo League established with its residents in documenting their living conditions.

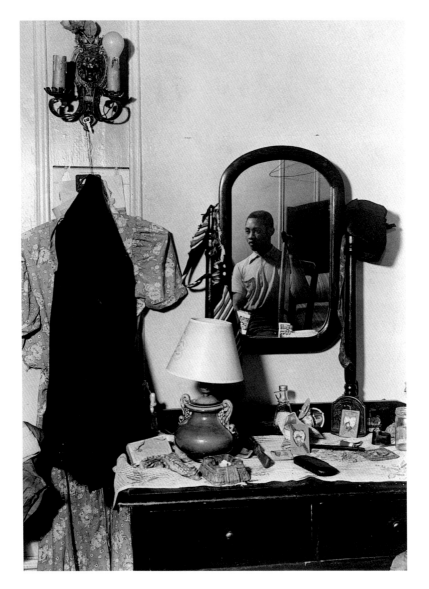

Savoy Dancers, Harlem Document, c.1935. For this image, Siskind – who loved to dance – set up two synchronized flash-guns and focused his camera, mounted on a tripod, on a certain corner of the dance floor. When he saw a pair of particularly good dancers, he asked them if they'd mind dancing over there. The elements that lift the image beyond simple documentation are, once again, tensions established by contrary motions. We feel the movement to the right the couple has just completed and, equally, the movement to the left they're about to make. We also see these complementary energies reflected in the composed happiness of the woman's expression and the abandon of the man's.

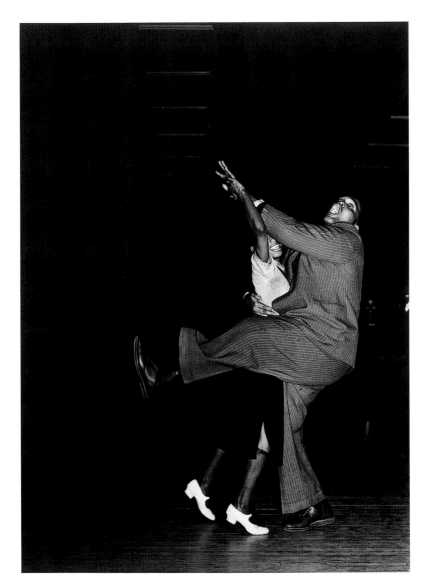

Dead End: The Bowery, c.1937. Depending on the state of relations between the United States and the Soviet Union, Communist Party functionaries alternately pressured the Photo League to portray the working class as noble or as destitute and exploited. Eventually Siskind became fed up with these pressures and left the group, but his sympathies with the poor and underprivileged never waivered. In terms of its symbols — shadows falling across a locked door, a suitcase battered and empty — this photograph may lack political subtlety, but Siskind's treatment of form and light invests it with human sympathy. The doorway seems sheltering, the shadows more comforting than ominous. A doorstep may be home, if only for a night.

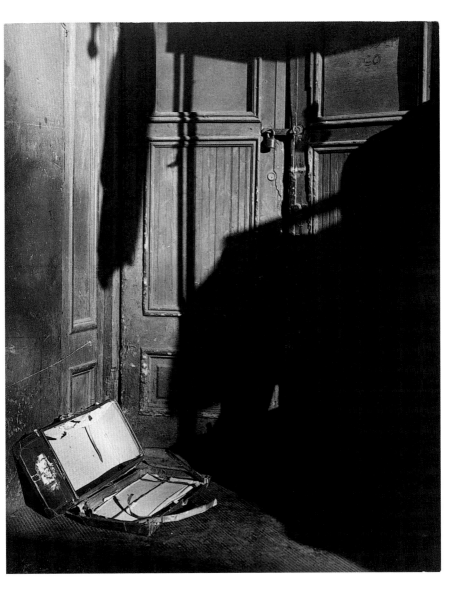

Tabernacle City 18, c.1935–8. 'Tabernacle City' was what Siskind entitled his documentation of the architecture of a Methodist summer retreat community called Cottage City in Massachusetts. At the time, Siskind considered it a documentary project in keeping with the aims of the Photo League, and he researched the community's origin and history as he had done for other projects. However, in a documentary film made just before his death in 1991, Siskind pointed to the delicately repeating shadows. These patterns were like music to him, he said, 'almost more important than the building itself'. In 1941 when Siskind exhibited the project at the Photo League's exhibition space, to his surprise, members saw it as a betrayal of 'the people'. Shortly thereafter Siskind left the group for good.

Martha's Vineyard, 1940. Siskind always spoke of 1943 as the turning point in his photography from documentary to abstract work, but careful research in Siskind's archive by his biographer Carl Chiarenza reveals that he was making fundamentally abstract pictures as early as 1940. The drama of the objects in this image derives in part from the fact that they are more implied than present. We see only the shadow of a glove on a post seeming to reach towards a cord. It is tempting to see the implied glove as foreshadowing Siskind's *Gloucester 1H, 1944* (page 33), in which, following his epiphany about what he was doing, a glove boldly confronts the viewer in full light.

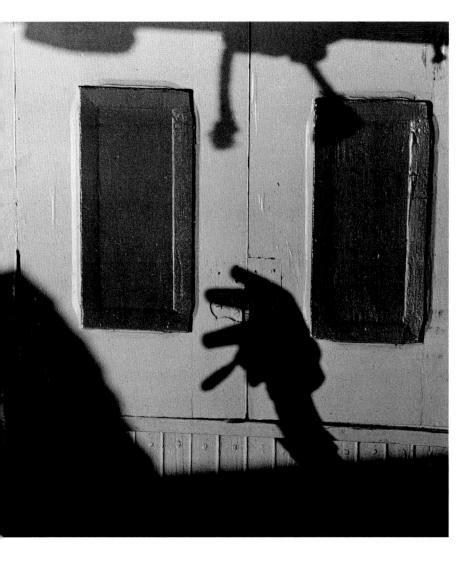

Gloucester 1H, 1944. This is one of Siskind's most famous images. It represents a critical turning point in his work. Siskind often said this photograph played an important part in teaching him what he was doing. 'By putting it in this frame, I had transformed a timid object … into a very powerful, demanding, confronting image,' Siskind told an interviewer in 1985. Siskind's use of a view camera in these early images played an important role in his evolving aesthetic. The swings and tilts between the film plane and the lens of the camera allowed Siskind to create a flat visual space in which all the pictorial elements were exactly parallel. Thus, he created a new space drawn from reality but also removed from it.

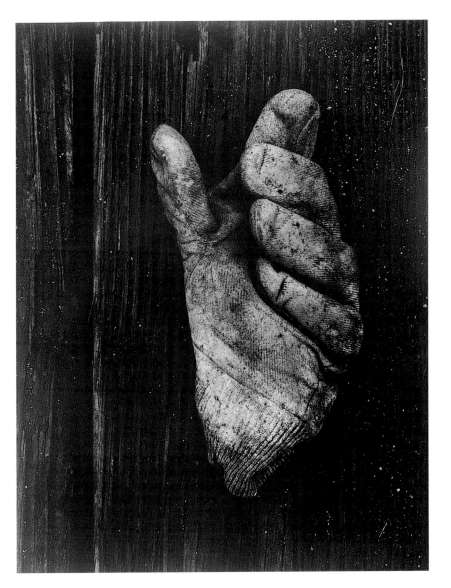

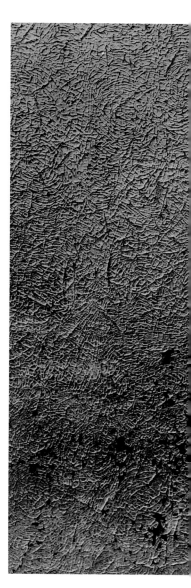

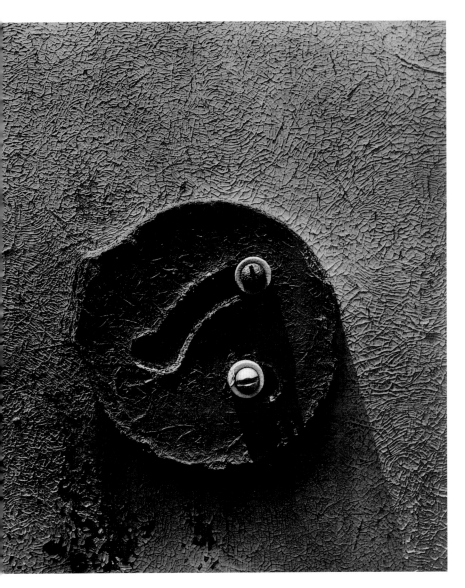

(previous page) Gloucester 1, 1944. While Siskind often spoke of form and the flat picture plane as the arena that allowed him to move from the bonds of 'illustration' in his documentary work to 'the realm of ideas' in his fine art photography, he remained equally sensitive to the less abstract matter of texture. Indeed as early as 1944, Siskind began experimenting with close-ups that emphasized texture as much as object and form. The texture of the wall in this image conveys an almost tactile connection between the object and the viewer. The machine plate seems to move across the plane like a planet in orbit carrying its homely duality of bolts together with their provision for necessary adjustment.

Gloucester 28, 1944. The dualities in a Siskind photograph often seem to form what he called a 'conversation' between two objects, two forms, two ideas. Siskind welcomed the fact that 'art begets art' and embraced the Judaeo-Christian vocabulary of Western art. He acknowledged that influence, sometimes describing his images as alluding to 'the Holy Family' or other biblical symbols. In an article on Siskind's early work in 1978, Chiarenza described this image as depicting 'a weeping Magdalen at the foot of the crucifixion', the isolation of the sexes or some other tragic dialogue. 'One feels a great impending violence which is momentarily stilled by the formal placement of shapes,' wrote Chiarenza.

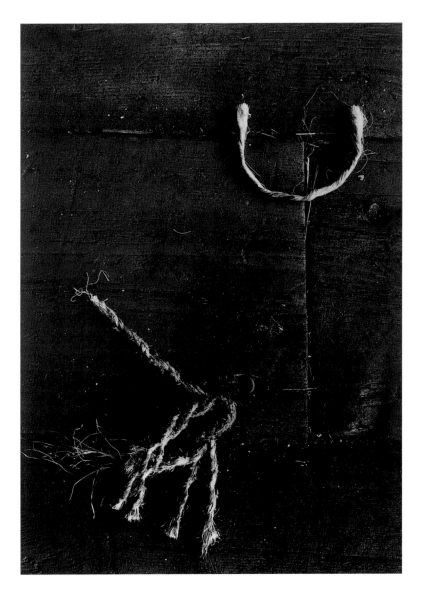

Gloucester, 1944. 'A picture experience is an experience that you can't say any other way,' Siskind often declared. 'It has to do basically with bringing order into our life. Think about the frame, the frame is always a powerful element ... It's a way of asserting that this is the product of a human mind that's operating. That's what I learned in Gloucester.' That summer his friend the painter Adolph Gottlieb rented a cottage there and Siskind rented a studio nearby. Each day, Siskind would set out alone to take pictures, giving himself only a limited number of exposures to make. Working like this opened up a world of freedom for him, and he would work like this for the rest of his life wherever he travelled.

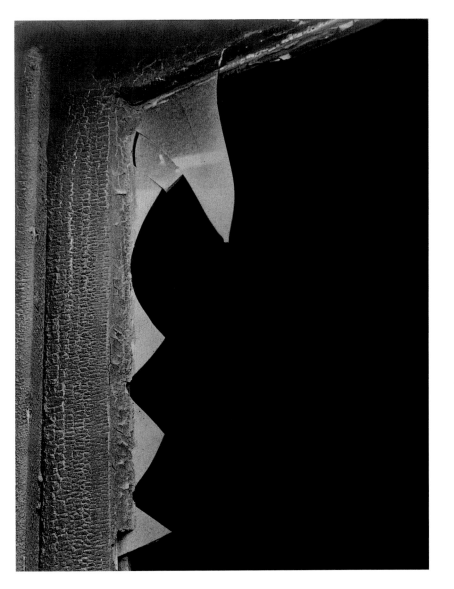

Gloucester 5 (Fist of God), 1944. In the spring of 1944 Siskind had photographed pre-Columbian sculptures for painter Barnett Newman in connection with a forthcoming exhibition. When he made his annual visit to the ocean that summer with the sculptures fresh in his mind, the rocks he had taken for granted now seemed transformed into 'very alive things' he could hardly bear to walk on. This particular image yielded a second revelation in 1947. That year, using it to convey a point about his work to a journalist who was writing a piece about him for *Mademoiselle*, he said, 'But all you have here are these *bones*.' Suddenly, the former English teacher and would-be poet began to appreciate how much metaphor influenced his picture making.

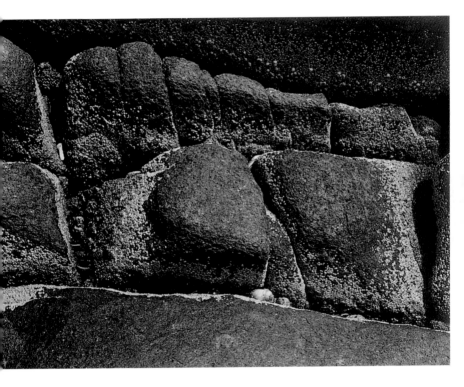

Untitled (Ironwork), c.1944. In the mid-1940s Siskind began to focus on the great variety of ironwork in New York City. In a fellowship application in 1945 he spoke of these ornaments as representing 'something of the nature of a folk art, expressive of the culture in which it operated'. Like the cottages of 'Tabernacle City', the ironwork represented the artifacts of a fugitive community. Siskind included this image in an article in *Art Photography* magazine in 1954 called 'This is My Best …', alluding to it as an example of the photographic transformation of objects: 'top of a tenement newel post – a primitive mask'.

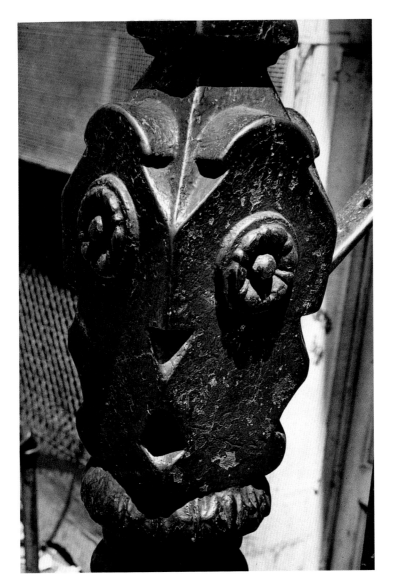

Return to Tabernacle City, 1946. After his love of abstraction fully awakened between 1943 and 1945, Siskind looked back on the artistic path he had followed so far. This image from a return visit to the Methodist community honours his own evolution as an artist. Here, objects are not implied, as in some Gloucester images from 1940 (page 31). Rather, they appear along with their shadow. The delicate tension between the way in which one projects and yet distorts the other is an emblem of the way in which Siskind said photographs 'pretend' to the resolution of 'sometimes fierce, sometimes gentle, but always conflicting forces.'

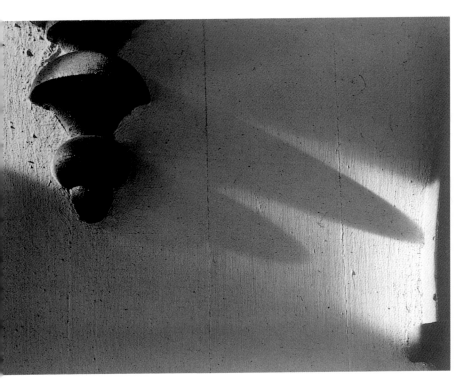

Chicago 8, 1948. Siskind made this image during the visit to Chicago when he met his great friend Harry Callahan for the first time. He used it as the cover image for his first book of photographs, which was published in Chicago in 1959. At the time he made the image, Siskind had just had his second one-man show at the Charles Egan Gallery in New York, a show immediately preceded by an exhibition of Willem de Kooning's black-and-white abstract paintings. Abstract Expressionism was firmly establishing its place in American art, and Siskind, already part of it, was turning his attention to markings on walls, something that would occupy a central place in his work for many years.

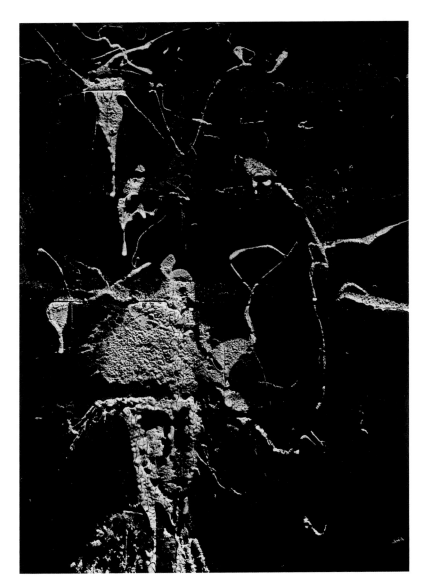

Maine 1, 1949. It was the music of Mozart, not Arnold Schoenberg, that Siskind most admired. Nevertheless, something Schoenberg once told his students offers an appropriate gloss to this image: music, he said, is about tension and release. Part of the drama of this photograph – the part stemming from its literal realism – lies in the tension of the paint adhering to the wall being released as it flakes away. Beyond realism, the relation of forms within the rectangle provokes tensions in fantasy as well. Are those storm clouds hovering above troubled waters? Is that form in the lower left a sea creature rising to menace the balloon-like escapee in the centre?

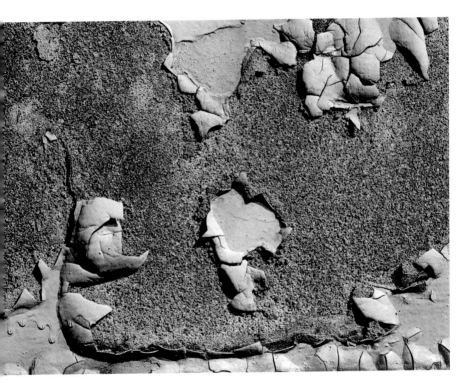

Jerome, Arizona, 1949. This image has remained one of Siskind's most exhibited and collected photographs. He made it with a 5 x 7-inch view camera on a day trip with Surrealist photographer Frederick Sommer to Jerome in Arizona, the famous ghost town. Much has been written about this image, but little addresses its enormous popularity. Perhaps that popularity arises from something beyond the photograph's stunning visual beauty – perhaps in part from its tactile appeal. Do we not want to touch these peeling paint chips, crack them off and help time along in its endless cycle of decay and renewal? The image offers something not just to look at, but also to engage with on a visceral, imaginative level.

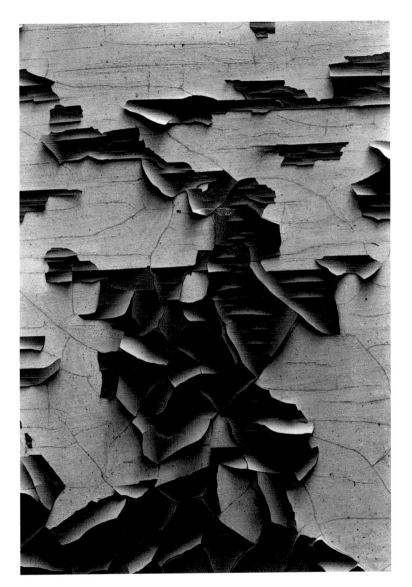

South Street 1947. Compositions of this kind, containing two shapes in seeming relation to one another, recur frequently in Siskind's work, as in *Gloucester 28, 1944* on page 37. He called them his 'conversation' pictures, reflecting once again his underlying concern with language, expression, relation and community. As Chiarenza wrote in *Aaron Siskind: Pleasures and Terrors* (1982): 'The shapes represent no one, but could well stand for anyone.'

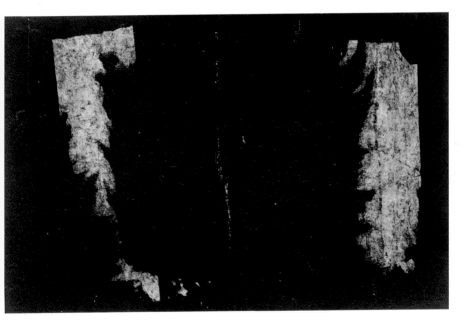

Martha's Vineyard, 1950. 'What is meaningful? What is beautiful? What is exciting? What stirs you? ... These are the things that matter, and in the end, it's the pleasure you get out of it. That's what it's all about. Art isn't necessary ... You could live without it, but you live much better with it.' (Aaron Siskind, Columbia College, 1982) This image prefigures a flood of similar ones created in 1954 (pages 62–3) and suggests Siskind's deep interest in relationships, the delicate balances of dependence and interdependence and of strength. Chiarenza suspects that his images from 1950 influenced Robert Motherwell's *Spanish Elegies*. This particular image appeared as the frontispiece for the first issue of *Modern Artists in America* (1952) edited by Motherwell among others.

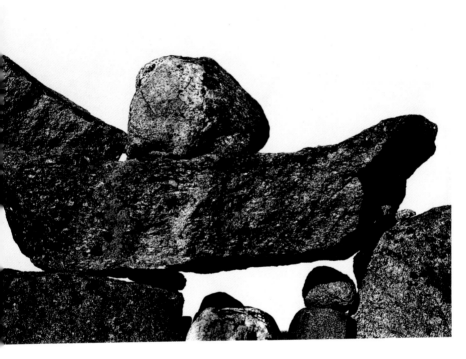

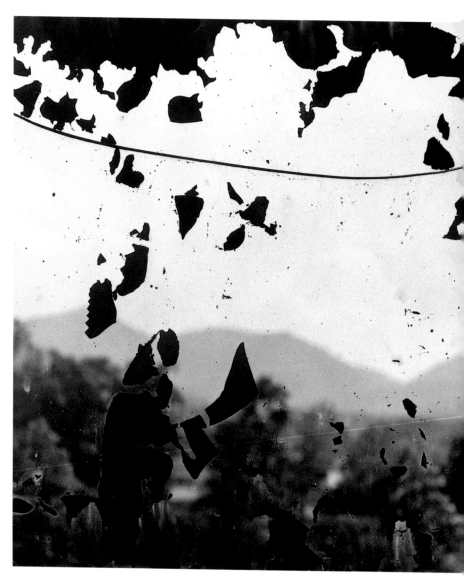

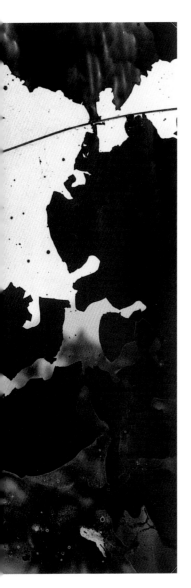

(previous page) North Carolina 9, 1951. Siskind displays a visual virtuosity in this photograph similar to that shown in *Chicago 224, 1953* (page 61). Here, viewers can clearly see hills in the background, and yet there is no background. The opaque shapes – perhaps the remains of signage on a window – act to compress near and far distances into a single picture plane. Nothing remains static, however. As the opaque fragments seem to rain down from above, a dark, thin line seems to move in contrary motion across the picture, even as it echoes the faint outline of the distant and not-so-distant hills.

Chicago Façade 13, 1952. Siskind's interest in architecture continued throughout his career. In this façade, his desire for order finds expression in a lyrically asymmetrical balance. It's a balance of time as well as form. Only the grand arch from an earlier doorway remains. A more modest entryway now takes its place.

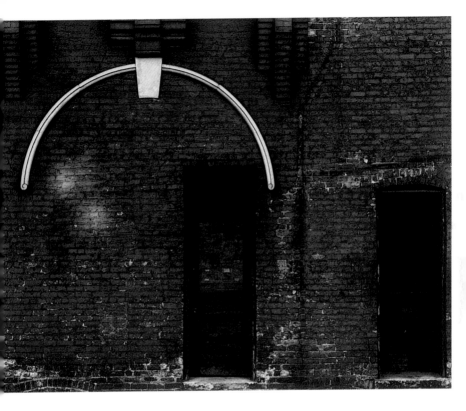

Chicago 224, 1953. In this image – working within the self-imposed limitations Siskind created for himself in essentially abandoning three-dimensional perspective in his photography – he demonstrates his virtuosity. Without perspective, the image still conveys a strong sense of depth. We see that there are layers to it; that the words 'I want a raise in work' seem to float over surfaces receding behind them. Here, Siskind's socialist ideals, which he passionately believed in long before he joined the Photo League in New York, emerge as a universal sentiment which even a dark background cannot obscure.

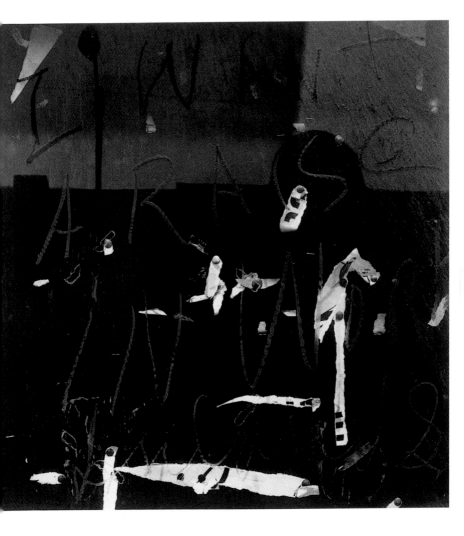

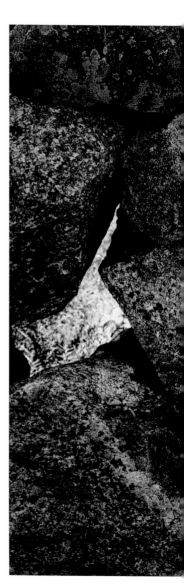

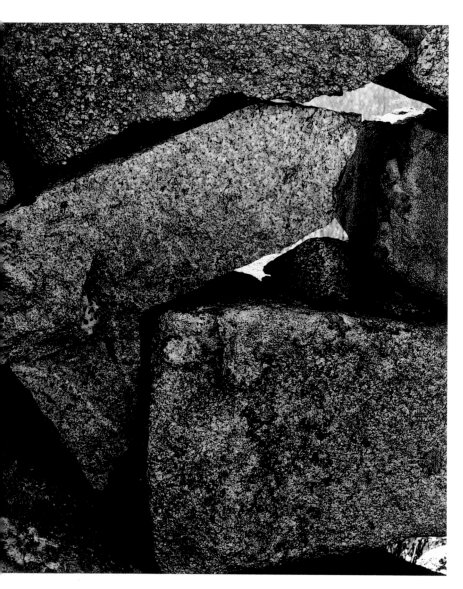

(previous page) Martha's Vineyard, 1954. Inner pleadings – often unconscious – guided much of Siskind's work. He was answering such a pleading when he began photographing rock walls in 1950 (see also page 55). He continued to photograph them for several years and, reflecting on the images later, came to see them as a 'document of my philosophy', especially regarding family: 'the importance of how people feel in relation to each other, the nearness, the touch, the difference, say, between a mother and her children and how she touches them and hovers near them and how a father does. It's completely different.' The pictures, he said, were about 'this whole business of contiguity' – the proximity and dependence of community.

Pleasures and Terrors of Levitation 474, 1954. Why did Carl Chiarenza adopt this series title as the title for his 1982 biography of Siskind? And why have these images – which seem at first glance so different from most of Siskind's other work – become so well known? Chiarenza writes: 'Levitation, balance, equilibrium, the controlled formal composition: all are pivotal points around which life in all its opposing dualities operates.' In a sense the 'Pleasures and Terrors' pictures offer a figurative analogue to Siskind's 'writing on the wall' or 'conversation' images, abstractions drawn from the leavings of time and human gesture. Here he conveys a sense not of history but of moment, of event, existential in its evocation of man's timeless condition, caught between ideals and realities.

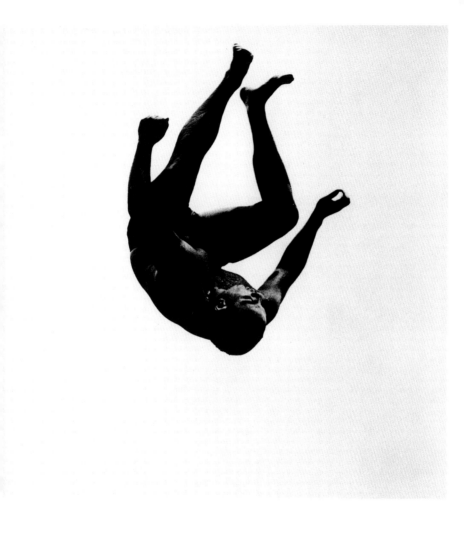

Pleasures and Terrors of Levitation 477, 1954. When Siskind began this series in 1953, he had no title in mind. He often set off to photograph open to what events might offer, rather than with preconceived ideas. In a documentary film about his life from 1991, he said, 'I'm unlike a lot of photographers in that for me the process of making a picture only begins when I click the shutter.' Clouds registered on Siskind's negatives, but he eliminated them in his prints by strongly increasing the contrast. In some ways 'levitation' is an odd word for Siskind to have chosen, since it almost always implies magic, if not chicanery. Long before, however, he had written that his photographs only 'pretended' to the resolution of opposing forces.

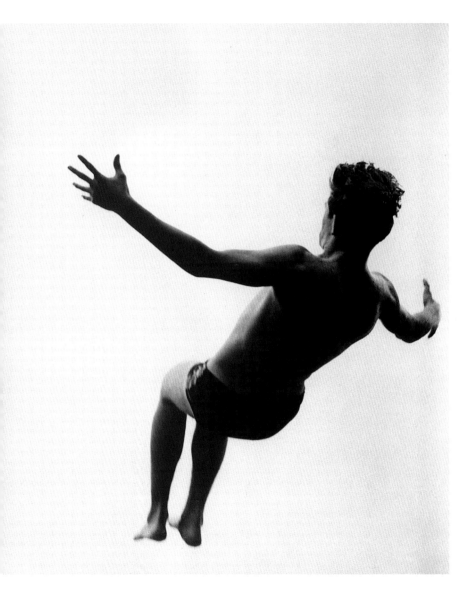

Yucatan 1, 1955. Siskind often described his lifelong fascination with fragments of language and lettering on walls as beginning with his reading of the Bible, citing the passage in Daniel (5:25) where a hand appears and writes words upon the wall that Belshazzar cannot translate. The king, however, feels their mysterious judgement. Daniel's declaration that they mean 'You have been weighed in the balance and found wanting' confirms his foreboding. For Siskind such markings evoked, among other associations, memories of his father writing Hebrew characters. Of the writing on the wall, he said, '[it] looks like it means something, but you'll never know what it means.'

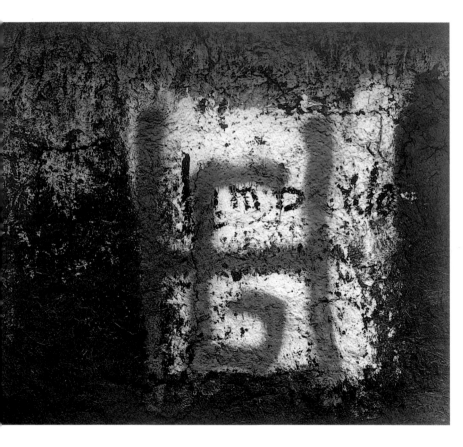

Yucatan 5, 1955. Often writing on a wall becomes indecipherable because it has been written over by a second hand with a different message. If the biblical origin of Siskind's interest in such markings echoed his persistent criticism of himself as an individual artist, he took pleasure in the communal implications of the 'overpainting'. He saw these photographs as collaborations, the product of a tiny community, two authors and himself. No individual grasped the whole, yet together they created an image that was meaningful in its mystery. 'Nobody makes photographs by themselves,' he once declared, 'it's all made in groups.' If art made demands of individuals, it also reflected and rewarded communities in both abstract and practical ways.

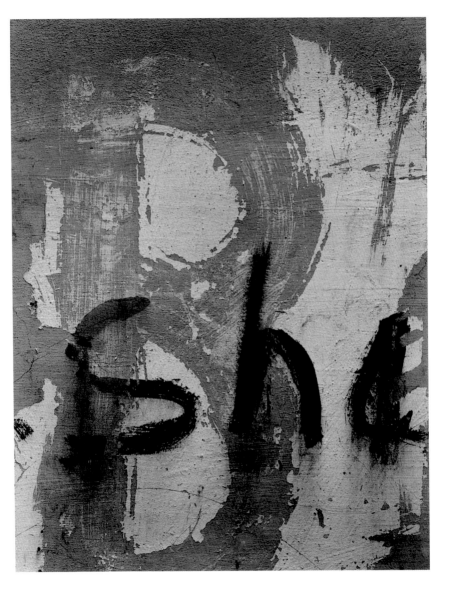

Feet 93, 1957. Siskind began photographing feet while studying divers at Chicago's Oak Street Beach. 'It has something to do with my kind of wallowing in something,' he told students years later, 'because feet to us, culturally, are something we try to forget about.' Siskind had always concentrated on things we try to forget are there – graffiti, discarded objects. Feet were different though. They were the other end of the spectrum: gravity made feet the foundations of our bodies, and it was gravity that was at the heart of Siskind's 'Pleasures and Terrors' pictures (pages 65, 67, 83, 85 and 87). Of the feet images he said, 'Some are lovely, some almost obscene: it's almost like I don't know what the hell I'm doing'.

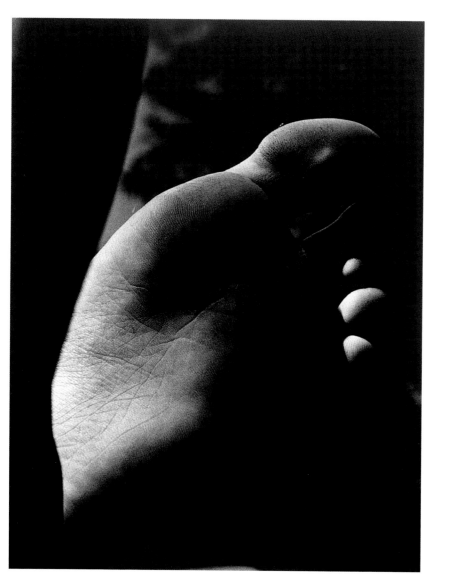

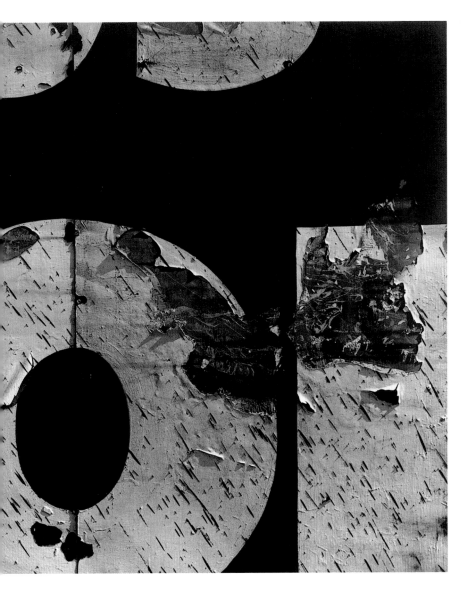

(previous page) **Chicago 22, 1957.** Just as the notes B-A-C-H (B flat) sometimes appear as a motif in Bach's music, so, too, do letters from Siskind's name appear in his photographs, especially – according to the critic Sheryl Conkelton – those made after his encounter with the poet Charles Olson at Black Mountain College in 1951. Olson felt that language conveyed beauty through 'these particles of sound' as much as through the sense of words. Often it is the A, R or S that appear in Siskind's photographs, but here it's the O. '[Music] is the purest art and the deepest,' Siskind told an interviewer in 1970. 'You never feel anything more deeply about life and meaning and destiny … than when you're listening to music, and yet, it's the vaguest.'

Chicago 17, 1960. 'Pressed for the meaning of these pictures, I should answer, obliquely, that they are informed with animism – not so much that these inanimate objects resemble the creatures of the animal world (as indeed they often do), but rather that they suggest the energy we usually associate with them … Essentially, then, these photographs are psychological in character … The interior drama is the meaning of the exterior event. And each man is an essence and a symbol' (Aaron Siskind, 'The Drama of Objects', 1945).

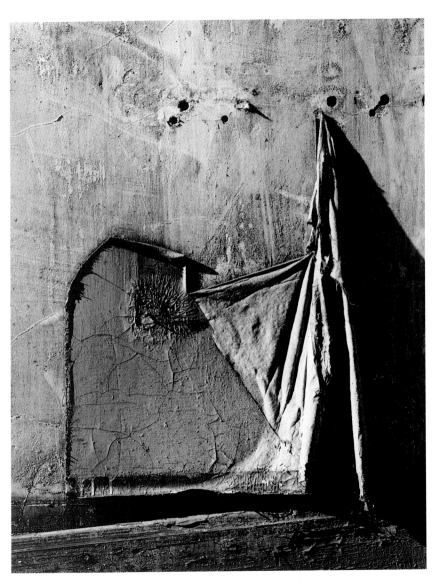

Chicago 56, 1960. On one level, we cannot know what these marks in one of Siskind's best-known images were about. (An electrical diagram, part of a construction site, perhaps?) On another level their expression of a universal male–female relation is clear. While we can only speculate about the precise meaning of these markings, we can be more confident in knowing what their appeal was to Siskind. Often in his abstract work, Siskind sought out elements that suggest interaction, conversation, two beings coming together.

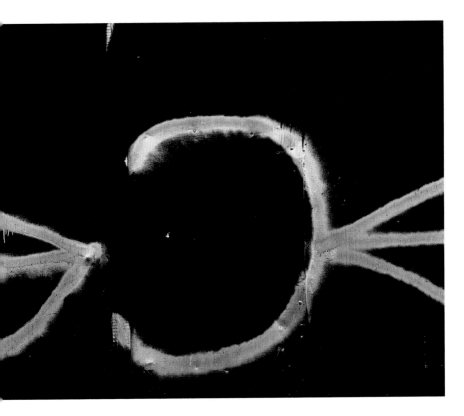

San Luis Potosi 16, 1961. Siskind's subject matter could, perhaps, be found everywhere, but he travelled a great deal to find it. 'Nothing was ever the same to me,' he told an interviewer in 1963. 'In each visit to a place – Martha's Vineyard, Mexico – I found a new element of mystery.' While these images from San Luis Potosi owe a major debt to Dada, as biographer Chiarenza suggests, they also convey 'a strangely quiet, calm pathos' that is Siskind's own.

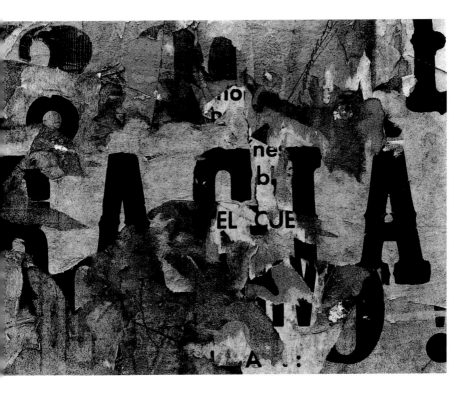

Pleasures and Terrors of Levitation, 1962. Siskind worked on the 'Pleasures and Terrors' series for more than ten years, during which time his 'picture concept' became more complex. 'The early ones were very pure and classic in form (pages 65 and 67),' he said, 'like a figure out of a Tintoretto or something, but the later ones get very baroque, very unpure, un-classical.' By 'baroque' Siskind seems to mean 'complicated' and 'ornate' compared to the more famous single-exposure images from this series. Siskind may have made single images from multiple exposures before, but this is the first significant example. Siskind did not consider himself an 'experimenter' and did not use multiple exposures again in this way until the Games Theater images of 1965 (page 89).

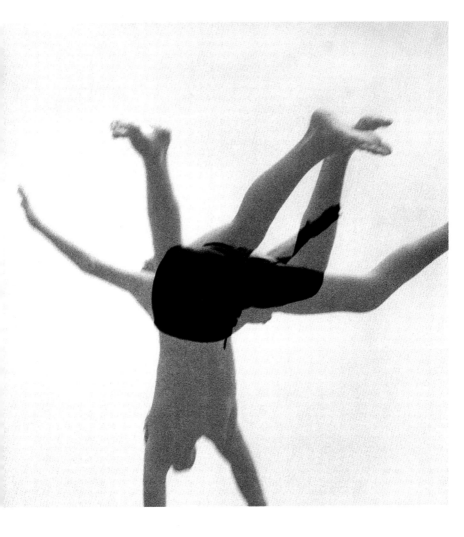

Pleasures and Terrors of Levitation, 1962. Siskind seldom utilized multiple exposures or photographed moving subjects using slow shutter speeds to achieve the blur or 'virtual volume', as it was called at the Institute of Design in Chicago. As his 'picture concept' for the 'Pleasures and Terrors' series became more baroque, however, he turned to them.

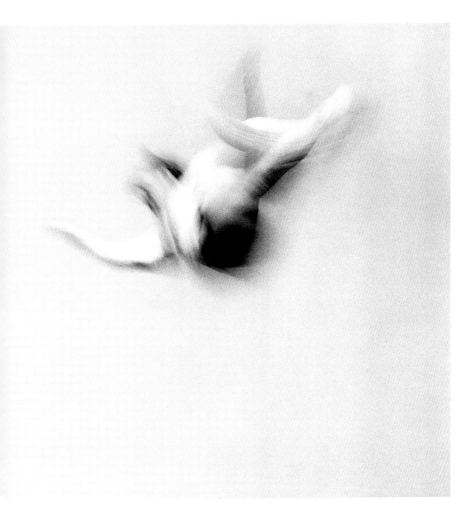

Pleasures and Terrors of Levitation 57, 1965. In the last pictures of this series, Siskind returns to the classical simplicity of the first ones (pages 65 and 67). While those images were infused with the exhilaration of uncertainty, these seem full of fateful resignation. It is the moment to come that commands attention – how will it feel to hit the water?

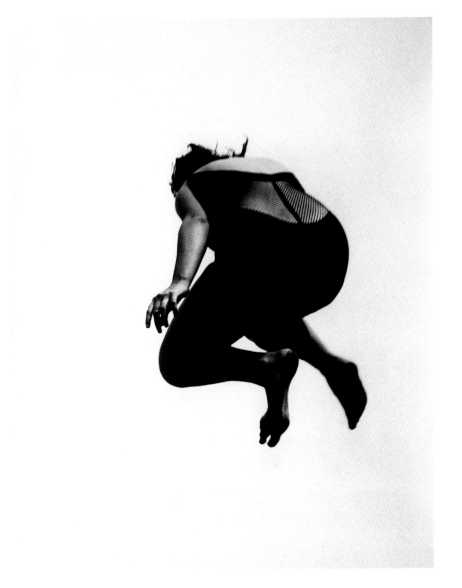

Games Theater 115, 1965. Siskind returned to the multiple-exposure technique here in order to become a silent witness–participant in an evening of improvisational theatre directed by Paul Sills of Chicago's Second City Theater Group. The Games Theater staged psychodramas in response to spare directions such as, 'Your sister has died: act accordingly, and continue until told to stop.' Moving among the actors onstage and with a hand-held camera, Siskind combined the layers of dramatic response in photographic collages. While Siskind rejected the idea that he ever 'experimented', he was always theatrical and these little-known images reflect his sympathy with theatrical moments and his willingness to try whatever suited his expressive needs.

Chicago 16, 1965. 'Art has to do with very fundamental things, like how stable you feel or how ephemeral you feel – a sense of destiny – or it opens up the abyss to you, this thing that you're afraid of, but you can face it when you see this thing.' (Aaron Siskind, 1970) Here the abyss appears as the missing centre of the poster. What was written on the poster? Was it vital information? In its absence viewers face only the importance of message, not the contents of a specific utterance.

Rome 67, 1967. Was Siskind still thinking of feet when he photographed this ruined monument? He had photographed it in almost exactly the same way in 1963 on his first trip to Rome around the time he produced his 'feet' pictures (page 73). In this image, time has worn away the rest of the body; only the part we try to forget about remains. The imprint of time as inescapable appears both here and in a large percentage of Siskind's work.

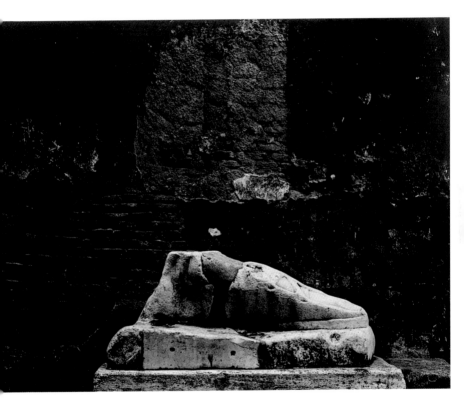

Martha's Vineyard 16A, 1969. Siskind described the photographs of dead leaves he made in 1969–70 as 'old man's pictures, what I was feeling then and now'. Events in 1969 split the world of Siskind's emotions violently. Surgery on his second wife Carolyn to replace two heart valves left her ailing in mind and body. Outwardly, praise of his work continued to shower on him; inwardly, he felt more alone than ever.

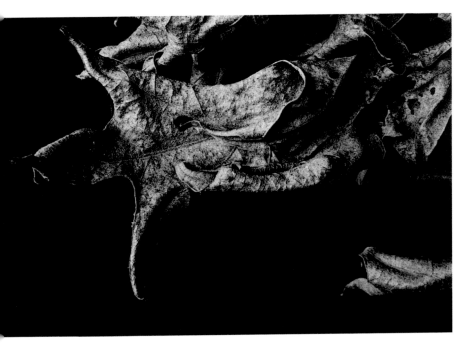

Olive Trees, Corfu 13, 1970. Siskind first encountered the Corfu olive trees during a side trip in 1967 while working in Rome. He returned to photograph them in 1970. He saw in them generations of age and experience, wounds and healing. He photographed them in ways that were, he said, 'almost like making the trees human'.

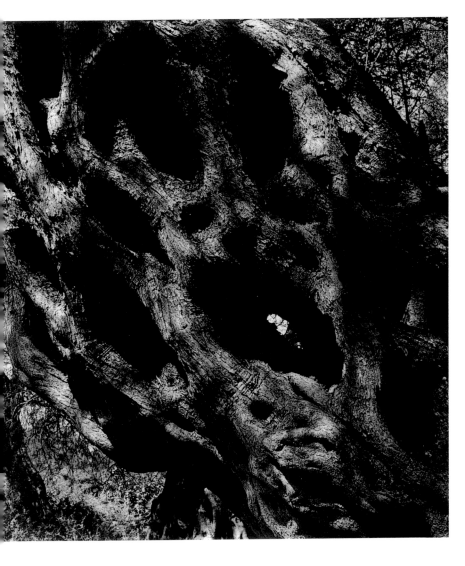

Old Horse 46, Chilmark, 1971. One thinks of Siskind primarily as a photographer of surfaces and forms, not as a photographer of light. But light guided Siskind's thinking and feeling in a variety of ways. 'It's like a nice bright light,' he said to an interviewer in 1974, describing his feelings when he found just the right words to get something across to students, or when he experienced an insight. In this photograph, the old horse becomes a venerable canvas for light. Life's larger animating reality is seen here as dappled abstraction.

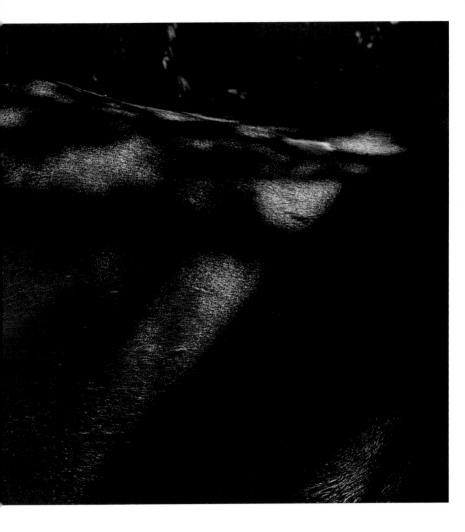

The Tree 35, 1973. 'You understand his tree,' writes critic Thomas B. Hess in his introduction to *Places: Aaron Siskind Photographs* (1976), 'you seem to have known it for as long as you've known the palm of your hand.' Siskind photographed this tree many times over the years, stopping on his way to a nearby doughnut shop, 'to see if anything was happening'. For him the tree was a vital symbol of life and change over time.

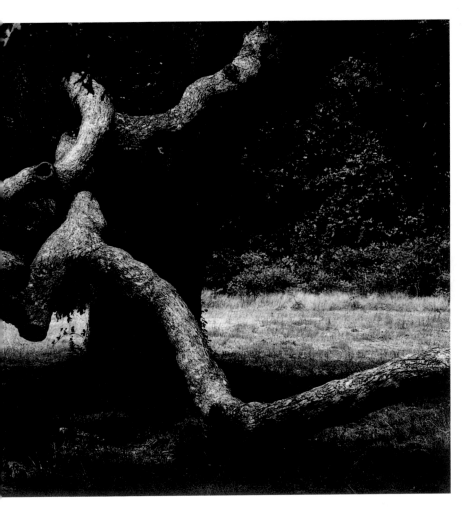

Homage to Franz Kline, Rome 69, 1973. Between 1972 and 1975 Siskind made approximately seventy-five images in his homage to his close friend the Abstract Expressionist painter Franz Kline. He had first thought of creating such a series in 1961, the year the seriousness of Kline's heart condition became known, but he did not begin work in earnest until 1972–3, in Jalapa, Mexico. When Kline died suddenly in 1962, for Siskind it came as a stroke of fate as bold as the broad brush strokes with which Kline had marked his canvases. An homage to such a vital friend seemed inevitable to Siskind almost from the moment of Kline's death.

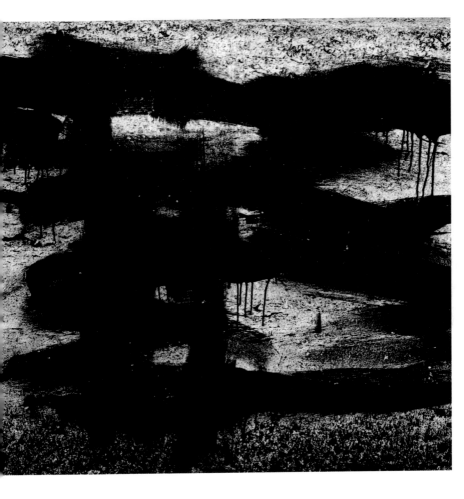

Homage to Franz Kline, Rome 150, 1973. Siskind made five groups of images for his homage to Kline, two in Mexico, two in Peru and one in Rome. In all of them Siskind explores, with Kline-like vigour and assertiveness, the compression of multiple layers of gestures into a single enigmatic plane. When he recalled in a 1980s documentary film how he began the homage, he described being inspired by turning a corner, seeing a marking on a wall and saying to himself, 'Franz was here.'

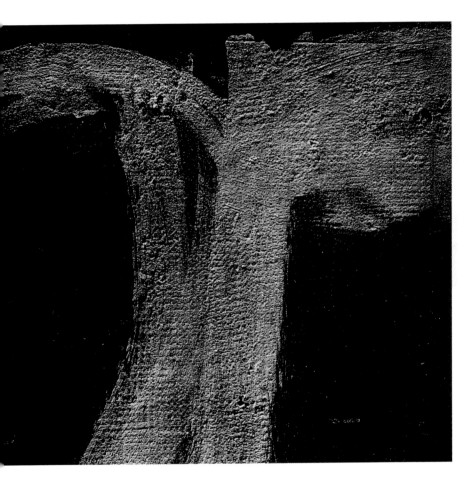

Homage to Franz Kline, Rome 145, 1973. Of his Abstract Expressionist friends, Franz Kline held a special place in Siskind's heart. Kline helped Siskind to get his first one-man show at the Charles Egan Gallery in New York in 1947 three years before Kline first exhibited there. The fact that Siskind's work received gallery recognition even before some of the most prominent Abstract Expressionist painters indicates the significant place he held in their company. The completed 'Homage' was first exhibited in Chicago in 1975. By then Siskind was near retirement and the exhibition became as much an homage to Siskind as to Kline. As a series, only the 'Pleasures and Terrors' images rival the 'Homage to Franz Kline' as an example of Siskind's inventive creativity at its most intense.

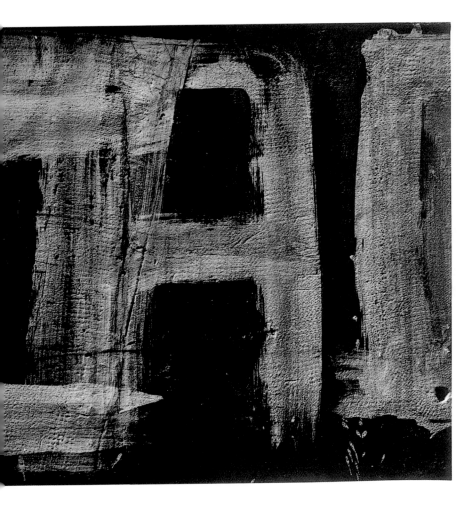

Homage to Franz Kline, Jalapa 26, 1974. In the 'overpainting' – the conflation of layers of expression captured in this image – it is as though Siskind has introduced echoes and cross-talk into his 'conversation' pictures. By placing the conversations one on top of the other, he creates monuments not so much to the idea of expression as to artistic expression's unending historical burden and ceaseless dance with ambiguity.

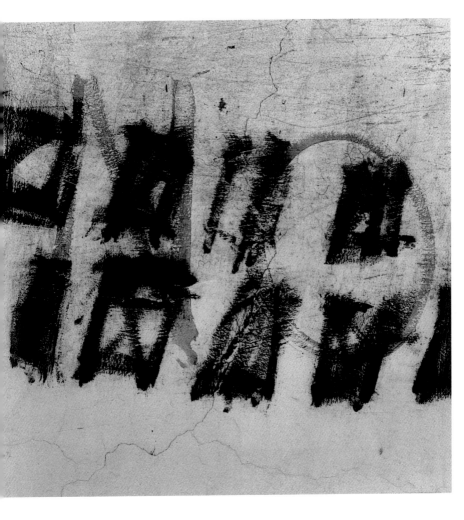

Homage to Franz Kline, Lima 19, 1975. The seated horseman and the poster fragment reading 'universidad nacional' (national university) make this image unique in the homage to Kline. It comes in the last group of homage images, and it has a less violent, more lyrical tone. 'What you see is what I selected,' said Siskind, 'and the very act of selecting and arranging gives order to the violence, tempers it. I place a configuration in the frame in a certain way which makes it more delicate – gives it a swing here and a bloom there – so that you go back to Franz through the wall but finally you reach me.'

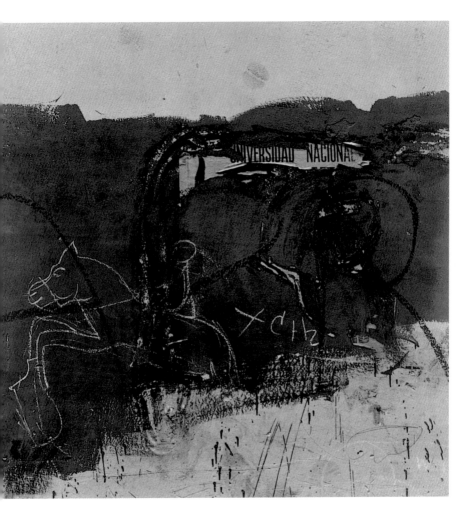

Louise 30, 1974. Though Siskind photographed many nudes, few of them equal the power of his work with other subject matter. This photograph is an exception. As in *Old Horse 46, Chilmark, 1971* (page 99), it is the light, not what it falls on that animates the picture. Late in life Siskind could still recite the Victorian poet Gerard Manley Hopkins's 'Pied Beauty' which begins, 'Glory be to God for dappled things', and ends, 'He fathers-forth whose beauty is past change: / Praise him.'

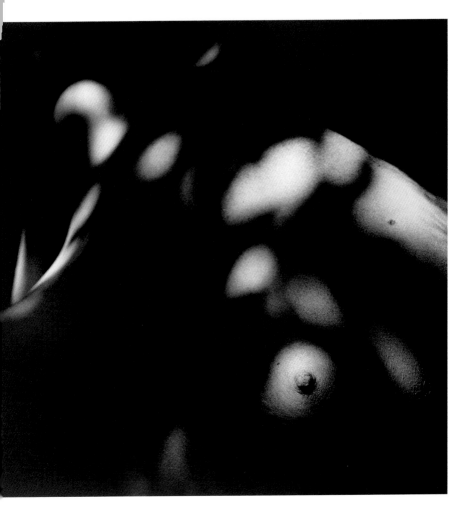

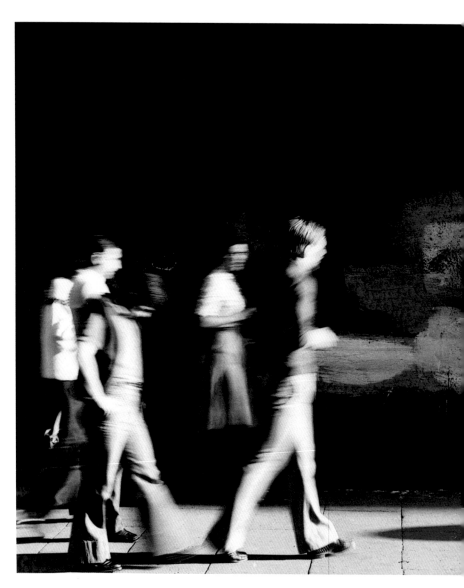

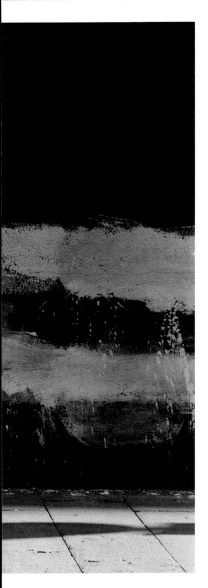

(previous page) Rome 135, 1977. Siskind's earlier work in Rome in the 1960s had explored its ancient statuary eroded by time (page 93). In this photograph, he uncharacteristically allows blurred motion (achieved by means of a slow shutter speed) to underscore the connection between living Romans, the transient markings they may make upon Rome's walls and the inescapable shadow of time into which they are forever walking.

Morocco 302, 1982. Following his long-standing aesthetic style, Siskind flattens and confines the contents of this image within the frame, but here he also invests the picture plane of this photograph with more depth than usual. As with the Corfu olive trees from ten years earlier (page 97), he pictures something organic in whose decay humankind may or may not have played a role. The hide, marked by the natural corruption of time, stiffens against the rough texture of a stone wall. As Siskind had written nearly forty years earlier, 'There is only the drama of the objects, and you, watching.'

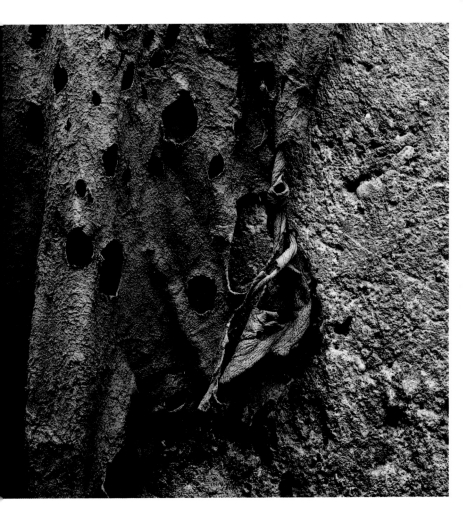

Salvador (Bahia), 1983–4. Throughout his career, Siskind occasionally made colour images, and he exhibited some of them near the end of his life, though none has ever been published before. Judith Jacobs, Siskind's assistant for many years, used to tease him that his colour was 'monochromatic'. In a way, she was right. These images – some of the only colour images Siskind ever exhibited – do function monochromatically for the most part, that is to say, they utilise largely uniform colour planes and are absent of significant gradation in hue or tint.

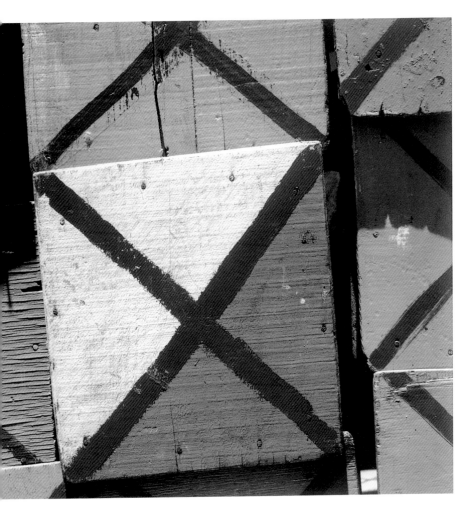

Salvador (Bahia), 1983–4. Both this image and the previous one show stools from above belonging to beachfront hire stands. Each stand's stools bear a different identifying pattern, and in the evening each stand owner collects his stools and piles them up for the next day's use. Siskind shot the distinctive patterns both in black and white and in colour, and both succeed as abstract compositions. The colour images, however, convey the sensuality and hedonism of the Brazilian beach just before the annual Carnival. These images make one wonder what fuller access colour might have given Siskind to the exuberant 'pleasures' which he often spoke of in his work, as contrasted with the 'terrors' so evident in black and white.

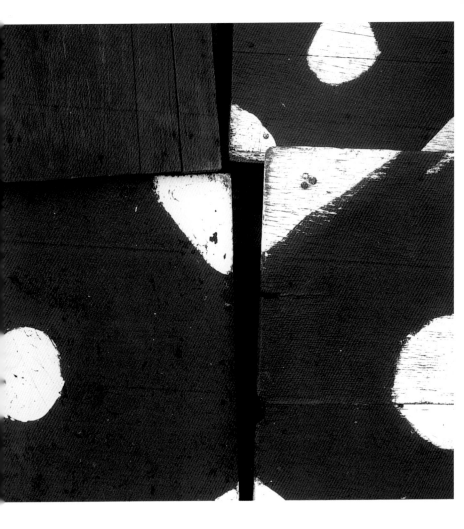

Providence 53, 1986. A few months before his death, in the last of several documentaries about him made during his lifetime, Siskind is seen padding down the shoulder of a two-lane highway on his last road trip, stopping from time to time to make images like this one from the 'Tar Series'. The two bold lines approach and then withdraw from each other, playing out Siskind's longtime preoccupation with dualities and opposing forces.

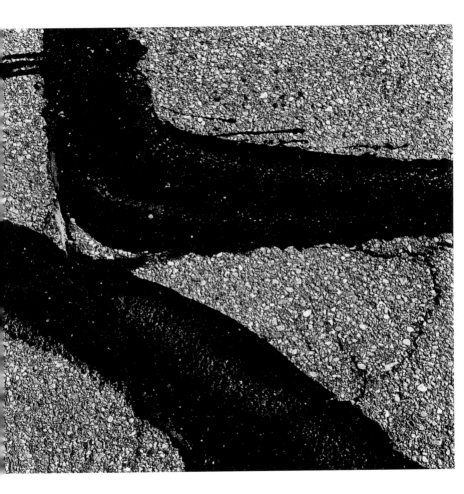

Vermont 51, 1987. Something has changed in these images. If his friend Franz Kline's lines were vigorous to the point of violence, Siskind's seem entirely lyrical. Furthermore, to underscore the excitement and possibilities, he prints these negatives so that the asphalt sparkles with the same energy to that felt in the line of tar that sweeps across the road, heading towards a destination that is – as always – somewhere just out of sight.

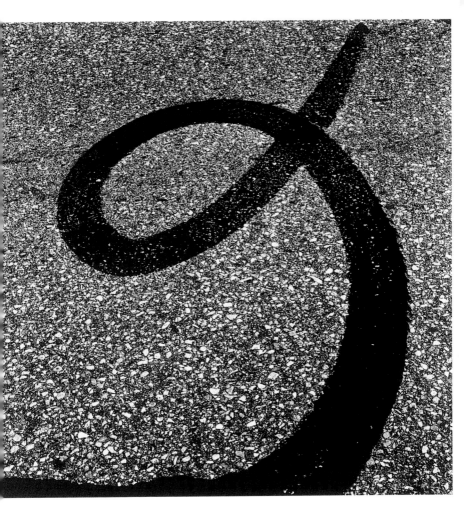

1903 Born 4 December, New York.

1915–26 Educated in New York at De Witt Clinton High School and City College where he gains a degree in Literature.

1926–47 Teaches English in New York state school system.

1929 Marries Sidonie Glatter. Receives first camera as a honeymoon gift

1932–35 Becomes active in the New York Workers' Film and Photo League Buys a Voigtlander Avus camera.

1936–41 Joins the reorganized New York Photo League. Establishes the Features Group, a documentary production unit, as part of the Photo League School. Produces group and independent photo-series including 'The Catholic Worker Movement' and 'Harlem Document

1940 Publishes 'The Features Group' in *Photo Notes*.

1943–44 Creates increasingly symbolic, abstract photographs based on discarded and found objects at Martha's Vineyard and in Gloucester Massachusetts.

1944 Publishes 'The Drama of Objects' in *Minicam Photography*. Establishes close and enduring ties to the Abstract Expressionist artists of the New York School.

1947–49 Teaches photography at Trenton Junior College, Trenton, New Jersey

1947–51 Exhibits regularly at Charles Egan Gallery, New York.

1950 Writes 'Credo', an artist's statement, for the symposium 'What is Modern Photography?' organized by Edward Steichen at the Museum of Modern Art, New York.

1951 Teaches with Harry Callahan during the summer at Black Mountain College in North Carolina.

1951–71 At the invitation of Harry Callahan, Siskind joins the faculty of the Institute of Design, Illinois Institute of Technology, Chicago. He is Professor of Photography there until 1959, when he become

Director of the Photographic Department. He leads and participates in advanced student projects including 'A Chicago Settlement House'. Travels in Greece and to Rome.

1952 Makes his earliest 'Pleasures and Terrors of Levitation' images showing bodies arrested in motion.

1956 With Harry Callahan, publishes 'Learning Photography at the Institute of Design' in *Aperture*.

1959 Publishes his first book of photographs, *Aaron Siskind: Photographs*.

1960–70 Becomes co-editor of *Choice* magazine.

1963–64 Founding member of the Society for Photographic Education and board member of Gallery of Contemporary Art, Chicago, Illinois.

1965 First major retrospective of Siskind's work, an exhibition of 200 prints, is organized by Nathan Lyons at the George Eastman House, Rochester, New York.

1966–83 Receives numerous awards, including: The Guggenheim Foundation Fellowship; Gold Star of Merit award from Philadelphia College of Art; a National Endowment for the Arts grant; and the Governor's Prize for the Arts, Rhode Island.

1969 Founding member of Visual Studies Workshop, Rochester.

1971–76 Teaches photography with Harry Callahan at Rhode Island School of Design, Providence, Rhode Island.

71–1991 An established photographer, Siskind continues to make photographs and is widely published and exhibited.

1984 Sets up the Aaron Siskind Foundation to inherit his vintage photographs. The income from their sale is used to support contemporary photography.

1991 Dies in Providence, Rhode Island, 8 February, 1991 at the age of eighty-seven.

Photography is the visual medium of the modern world. As a means of recording, and as an art form in its own right, it pervades our lives and shapes our perceptions.

55 is a new series of beautifully produced, pocket-sized books that acknowledge and celebrate all styles and all aspects of photography.

Just as Penguin books found a new market for fiction in the 1930s, so, at the start of a new century, Phaidon **55**s, accessible to everyone, will reach a new, visually aware contemporary audience. Each volume of 128 pages focuses on the life's work of an individual master and contains an informative introduction and 55 key works accompanied by extended captions.

As part of an ongoing program, each **55** offers a story of modern life.

Aaron Siskind (1903–1991) was an acclaimed photographer and teacher who sought to develop a new pictorial language for the medium. Best known for his abstract images, Siskind championed the importance of personal discovery in photography and was one of the most important photography teachers in America in the twentieth century.

James Rhem is the Executive Editor and Publisher of *The National Teaching and Learning Forum*. An independent scholar and curator, Rhem has published extensively on twentieth century photography and art, lectured widely on teaching, and is also a practising photographer.

Phaidon Press Limited
Regent's Wharf
All Saints Street
London N1 9PA

Phaidon Press Inc.
180 Varick Street
New York NY 10014

www.phaidon.com

First published 2003
©2003 Phaidon Press Limited

ISBN 07148 4151 X

Designed by Julia Hasting
Printed in Hong Kong

Photographs by permission of: Aaron Siskind Foundation courtesy Robert Mann Gallery; Portrait © Charles H. Traub 1971.